Faith in Bloom

Joe Nichols,

Thank you for sharing your music—
The best of Health and Happiness
to you and your Family.

Regards,

Thomas B---

Faith in Bloom

photography by

Thomas Brain

Rock River Publishers
Rockford, Illinois

Rock River Publishers
1657 Red Oak Lane
Rockford, IL 61107

Faith in Bloom

Printed in the United States of America

Order books from your local bookstore referencing the ISBN below,
or contact the author through his Web site:
http://www.thomasbrainphotography.com.
tombrain1@aol.com

ISBN-13 978-0-9778500-5-1

This book is dedicated to my supportive and very best half,
Kevin Ann, and to our always amazing sons, Tyler and Elliott.

A special Thank You to Marvin and Penny Mitchell and to Tiny and Doris Brain
for helping with life's needs and support.

Thanks to Susan and Ben Rubendall for their
expert knowledge of the publishing field.

Support the fight against cancer.
In Remembrance:
June Simon, Doris Brain, Cathy Downing, Johnny Kasch

Behold, God is my helper.

The Lord is the one who sustains my soul.

Psalm 54:4

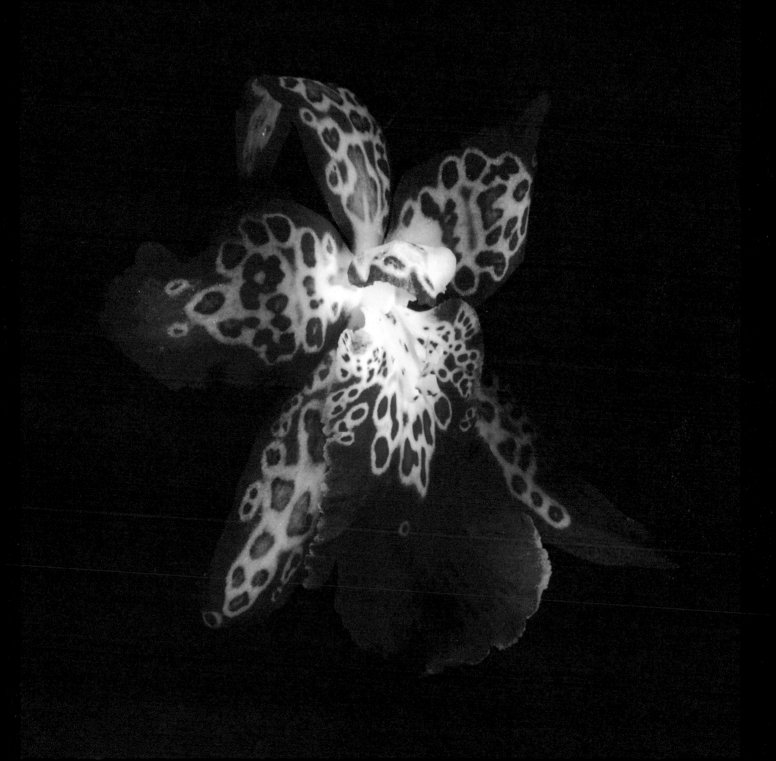

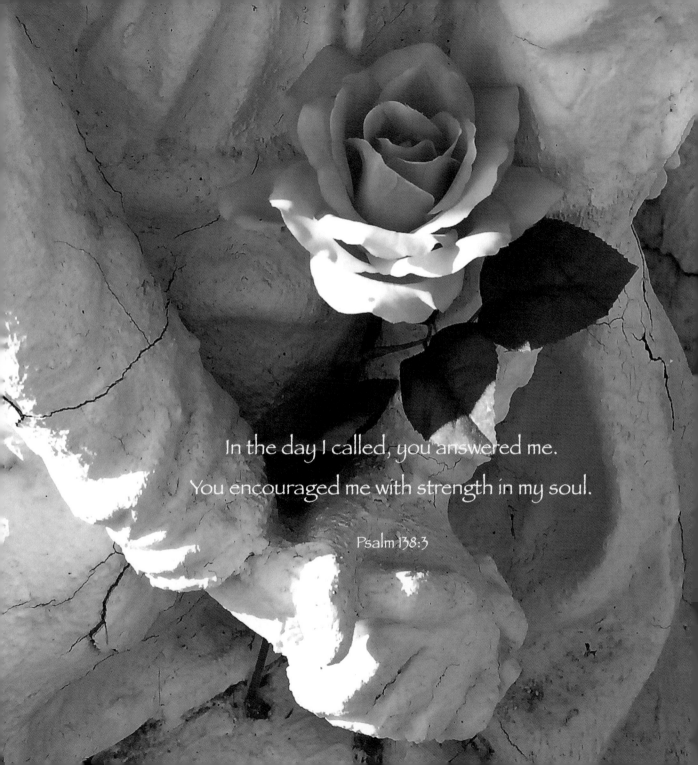

In the day I called, you answered me.
You encouraged me with strength in my soul.

Psalm 138:3

You are my hiding place
and my shield.
I hope in your word.

Psalm 119:114

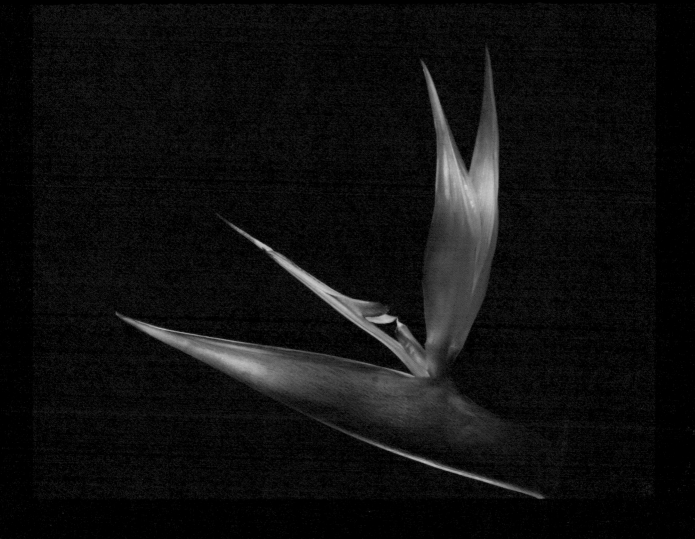

He alone is my rock and my salvation, my fortress —

I will never be greatly shaken.

Psalm 62:2

Be to me a rock of refuge
to which I may always go.
Give the command to save me,
for you are my rock and my fortress.

Psalm 71:3

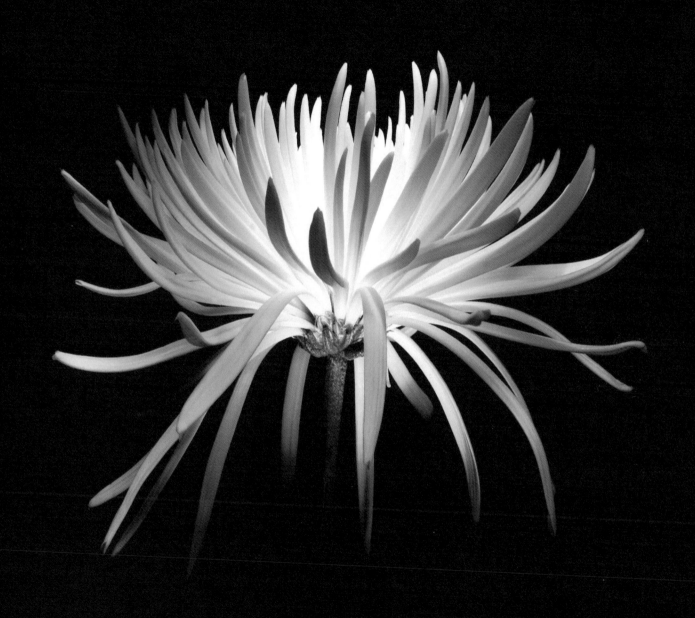

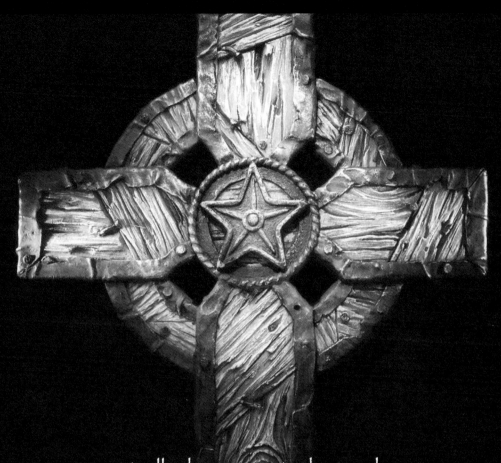

Finally, be strong in the Lord,
and in the strength of his might.

Ephesians 6:10

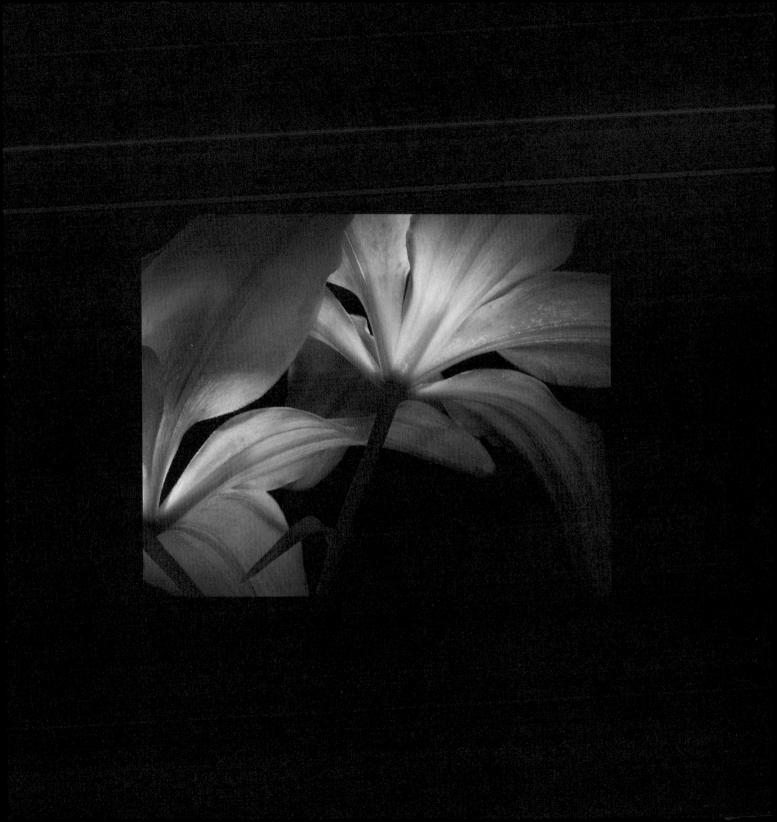

My flesh and my heart fails,
but God is the strength of my heart
and my portion forever.

Psalm 73:26

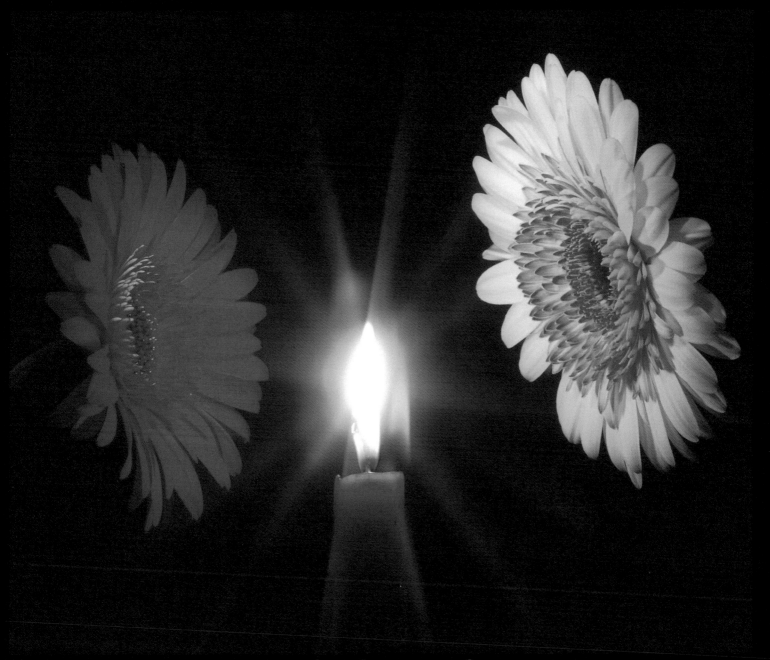

Your word is a lamp to my feet,
and a light for my path.

Psalm 119:05

When you walk,
they will guide you;
when you sleep,
they will watch over you;
when you are awake,
they will speak to you.

Proverbs 6:22

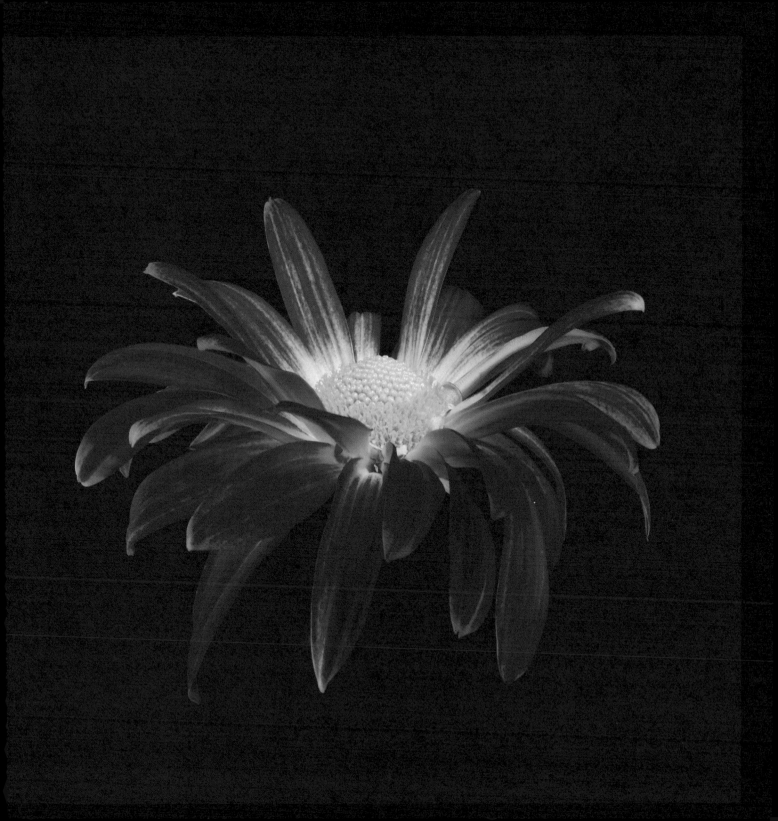

The Lord hath heard
and hath had mercy on me;
the Lord became my helper.

Psalm 30:10

My times are in your hand.

Deliver me from the hand of my enemies,

and from those who persecute me.

Psalm 31:15

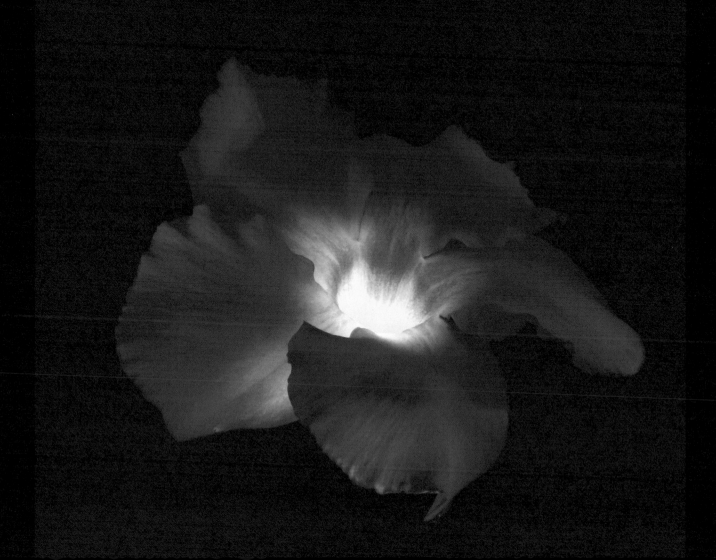

I will instruct you and teach you
in the way which you shall go.
I will counsel you with my eye on you.

Psalm 32:8

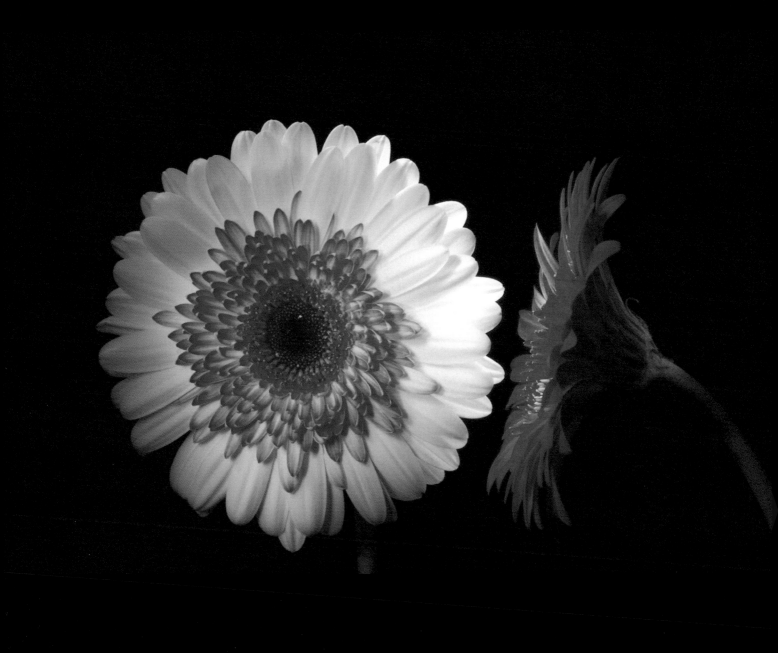

Humble yourselves
in the sight of Lord,
and he will exalt you.

James 4:10

My soul is weary with sorrow;
strengthen me according to your word.

Psalm 119:28

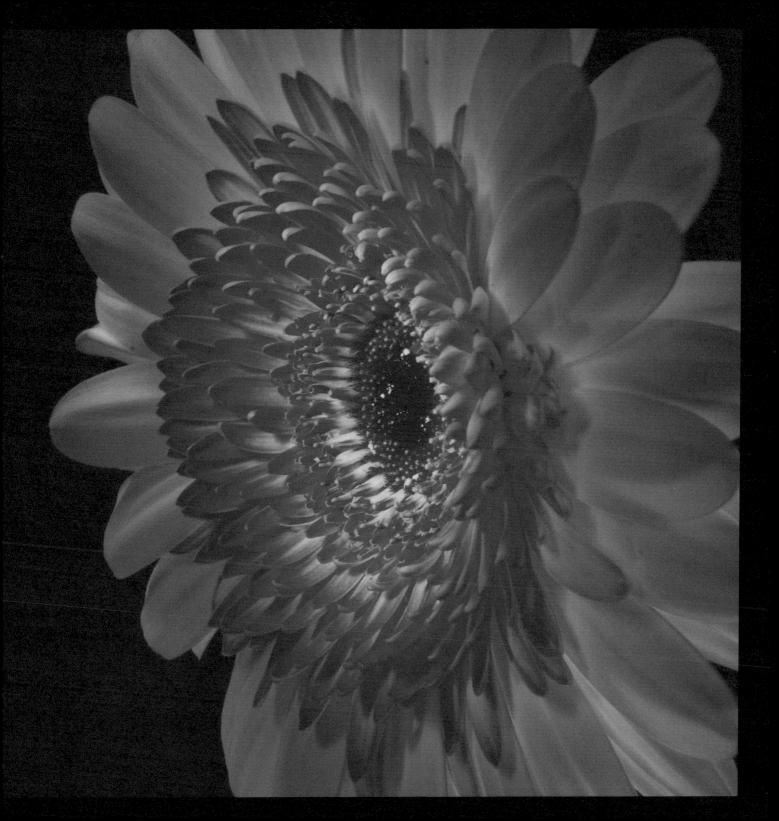

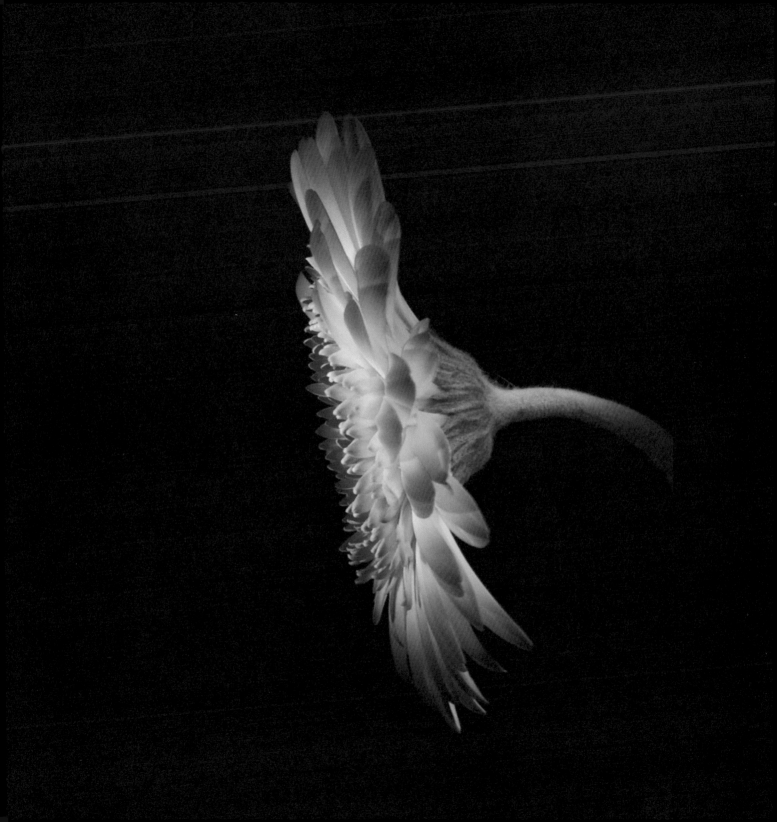

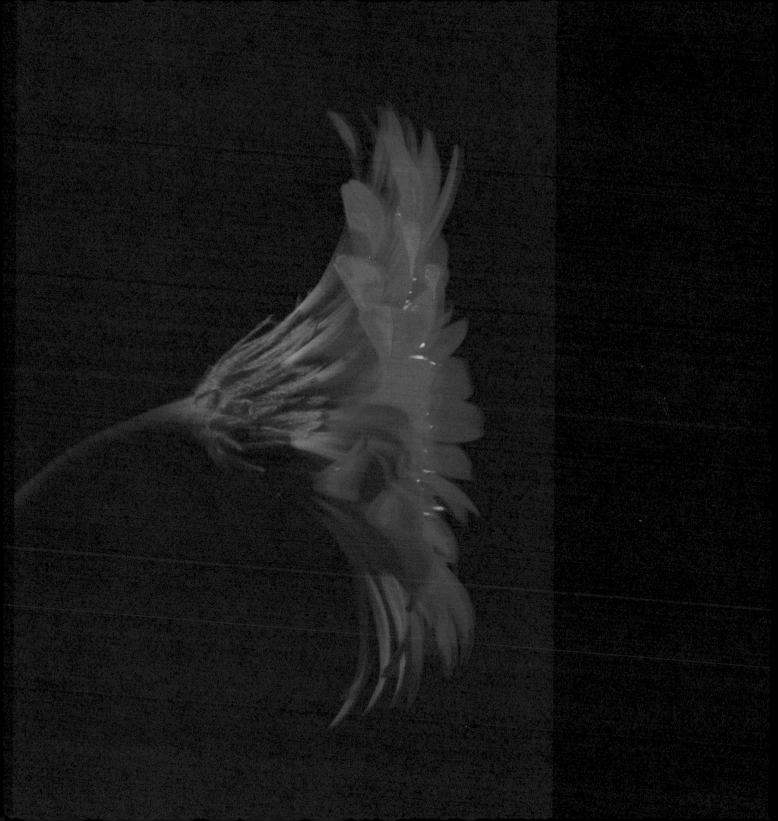

But I tell you,

Love your enemies,

bless those who curse you,

do good to those who hate you,

and pray for those who mistreat you

and persecute you.

Matthew 5:44

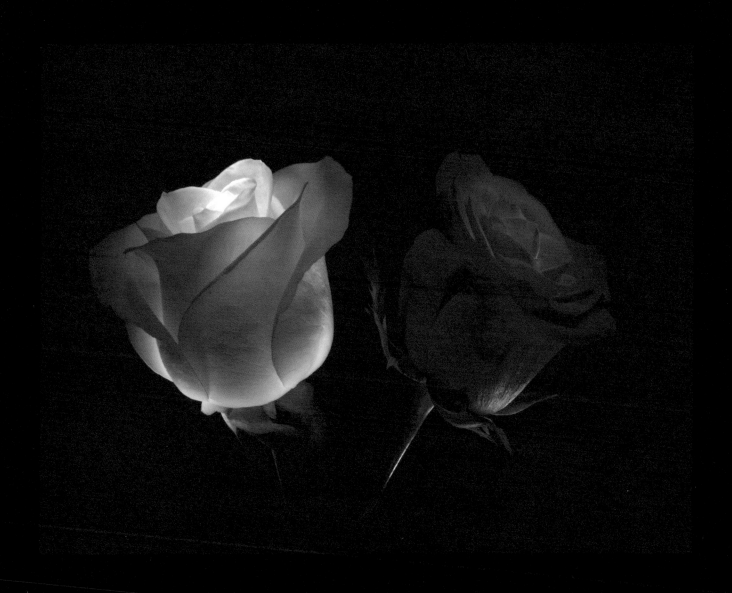

Call on me in the day of trouble.

I will deliver you, and you will honor me.

Psalm 50:15

But, they that hope in the Lord
shall renew their strength,
they shall take wings as eagles,
they shall run and not be weary,
they shall walk and not faint.

Isaiah 40:31

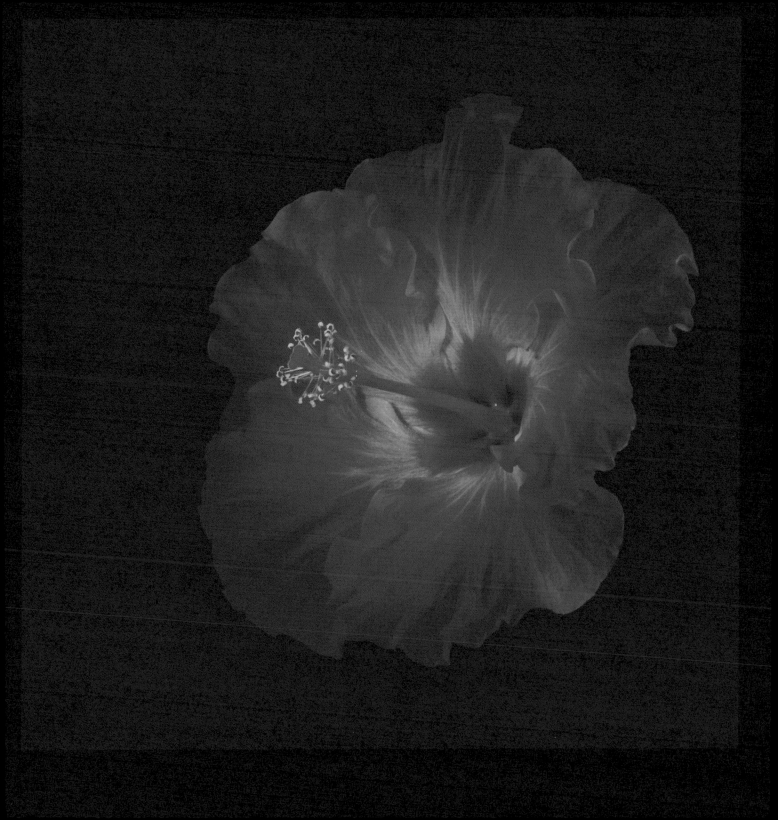

If you remain in me, and my words remain in you,
you will ask whatever you desire, and it will be done for you.

John 15:7

Humble yourselves, therefore,

under God's mighty hand,

that he may lift you up in due time.

Cast all your anxiety on him

because he cares for you.

1 Peter 5:6-7

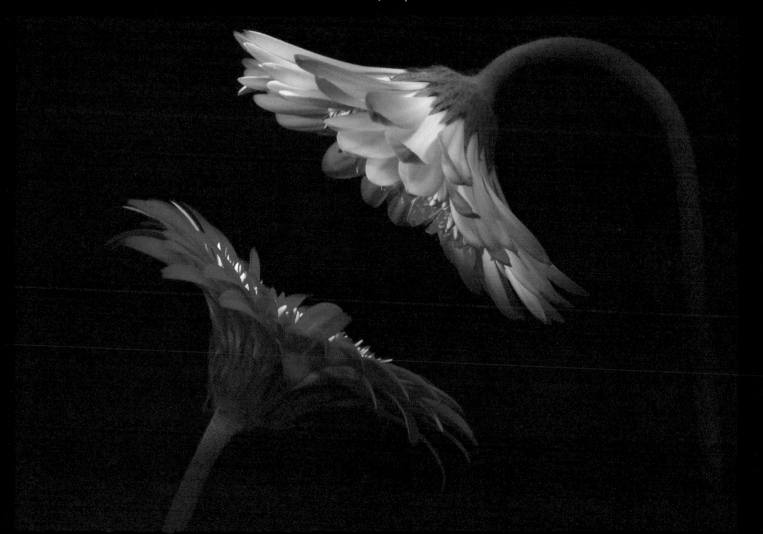

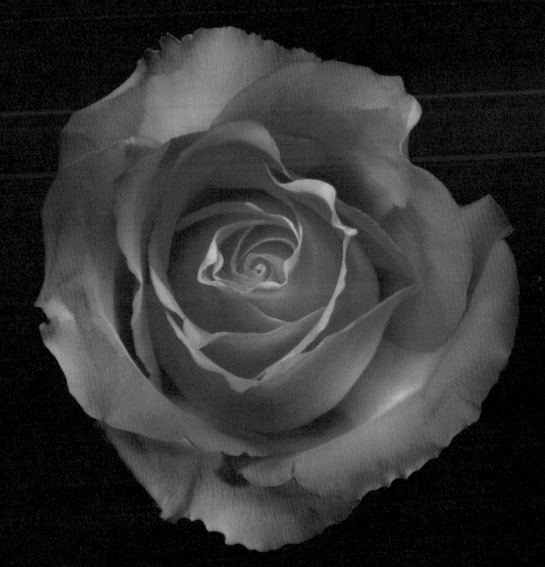

Even though I walk
through the valley of the shadow of death,
I will fear no evil, for you are with me.

Your rod and your staff,

they comfort me.

Psalm 23:4

The steps of a good man
are ordered by the Lord.

Psalm 37:23

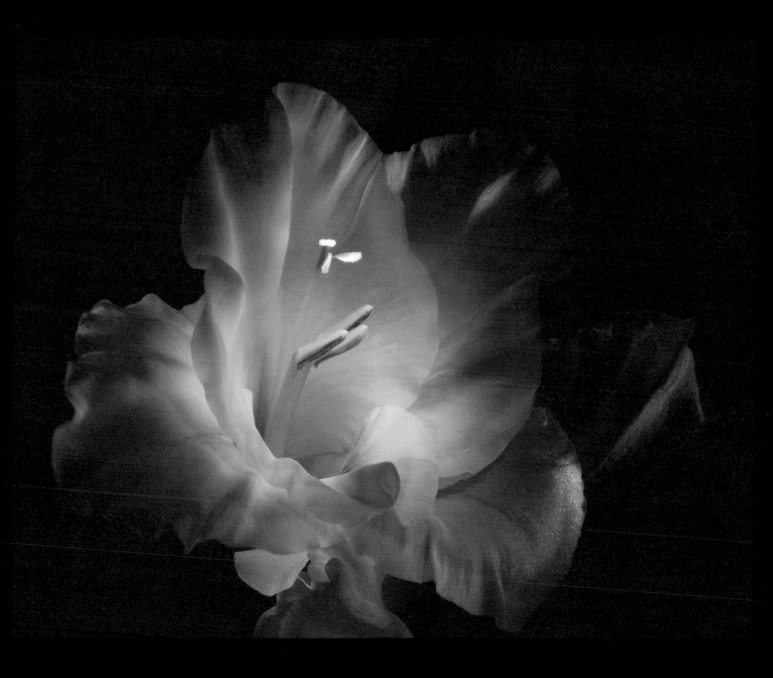

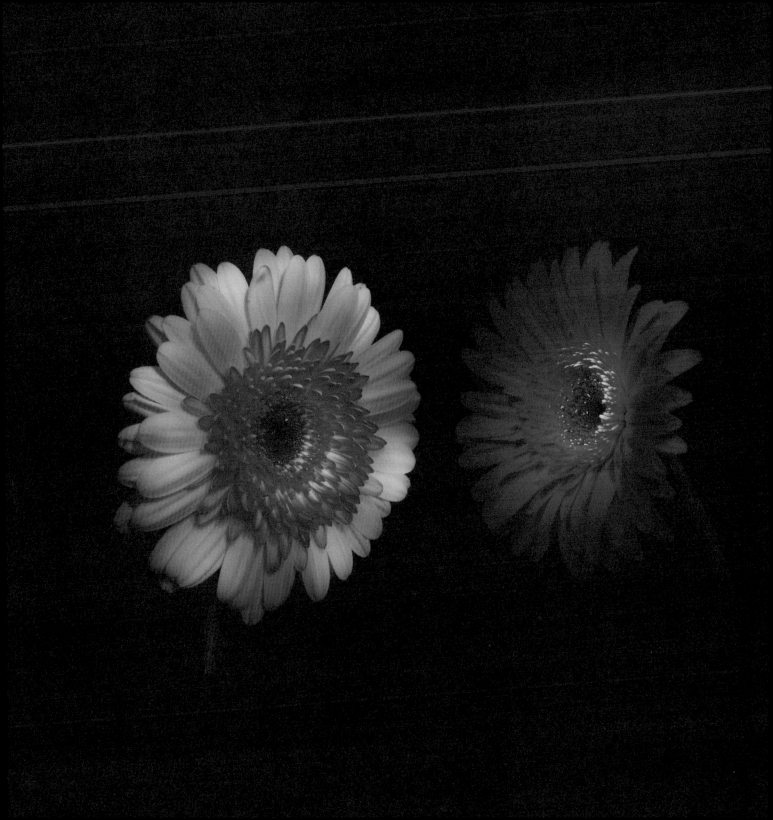

Don't you be afraid, for I am with you.

Don't be dismayed, for I am your God.

I will strengthen you.

Yes, I will help you.

Yes, I will uphold you

with the right hand of my righteousness.

Isaiah 41:10

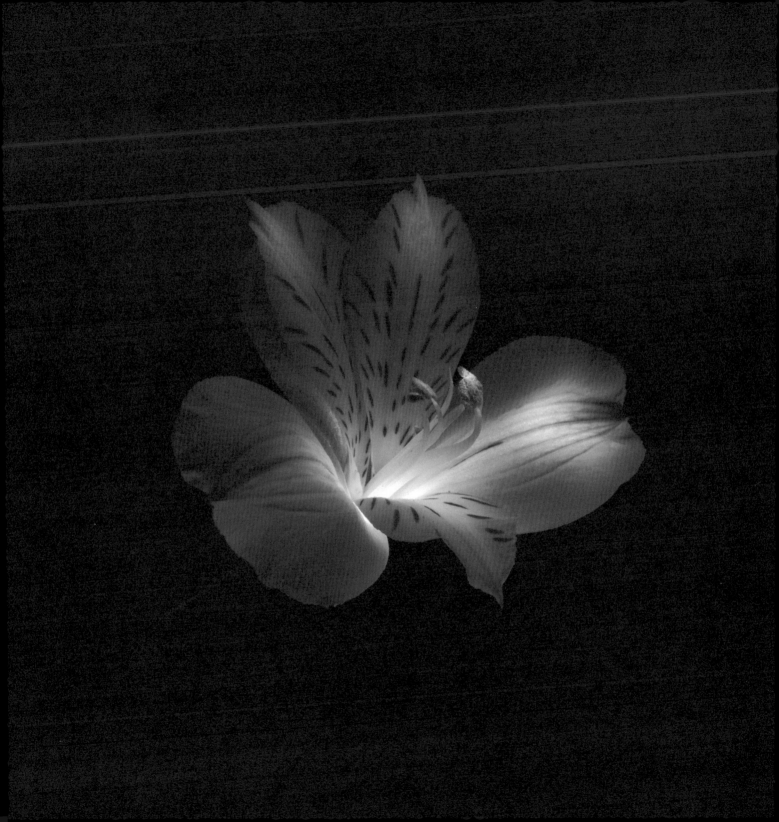

Trust in the Lord with all your heart
and lean not on your own understanding;
In all your ways acknowledge Him,
and he will make your paths straight.

Proverbs 6:22

My soul is weary with sorrow:

strengthen me

according to your word.

Psalm 119:28

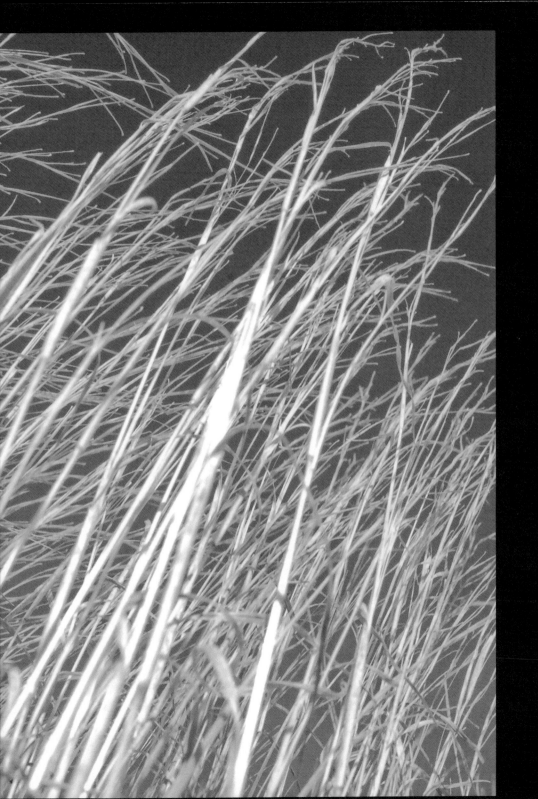

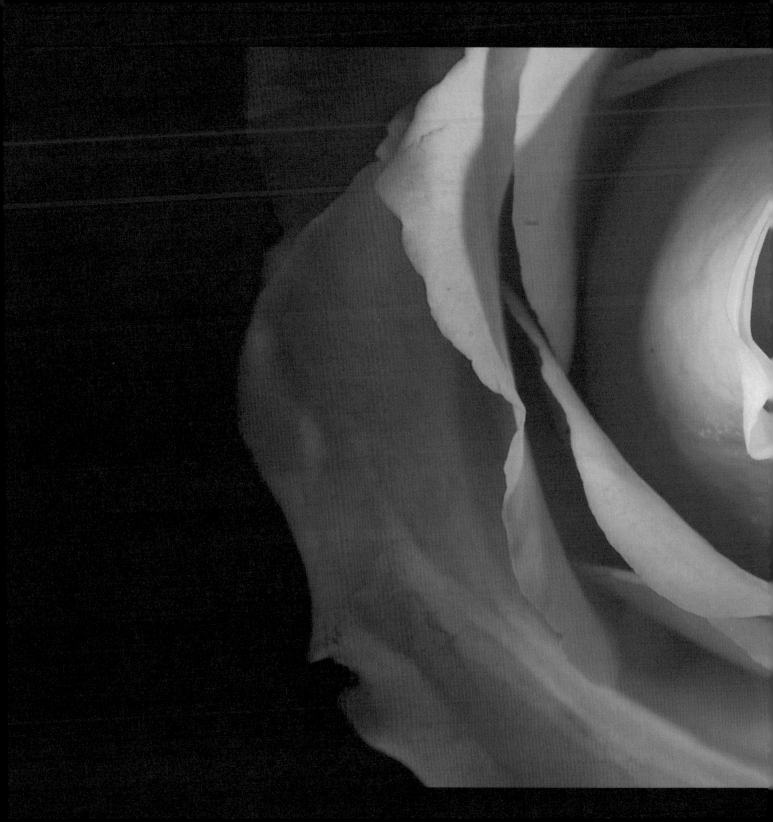

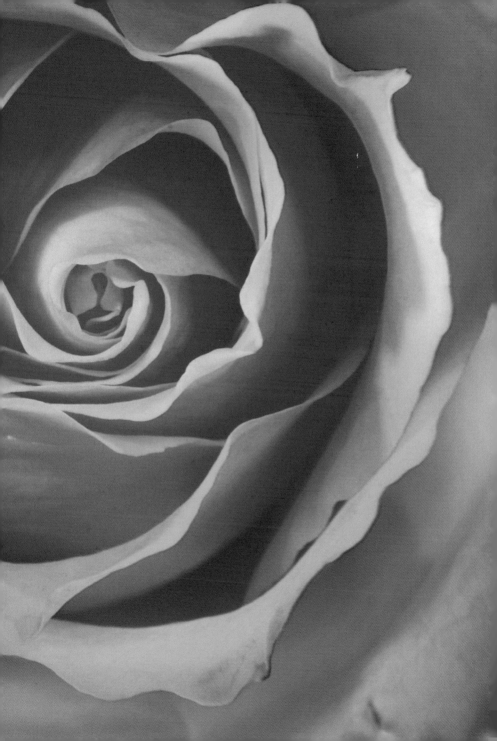

Do not be anxious about anything,

but in everything,

by prayer and petition with thanksgiving,

present your requests to God.

Philippians 4:6

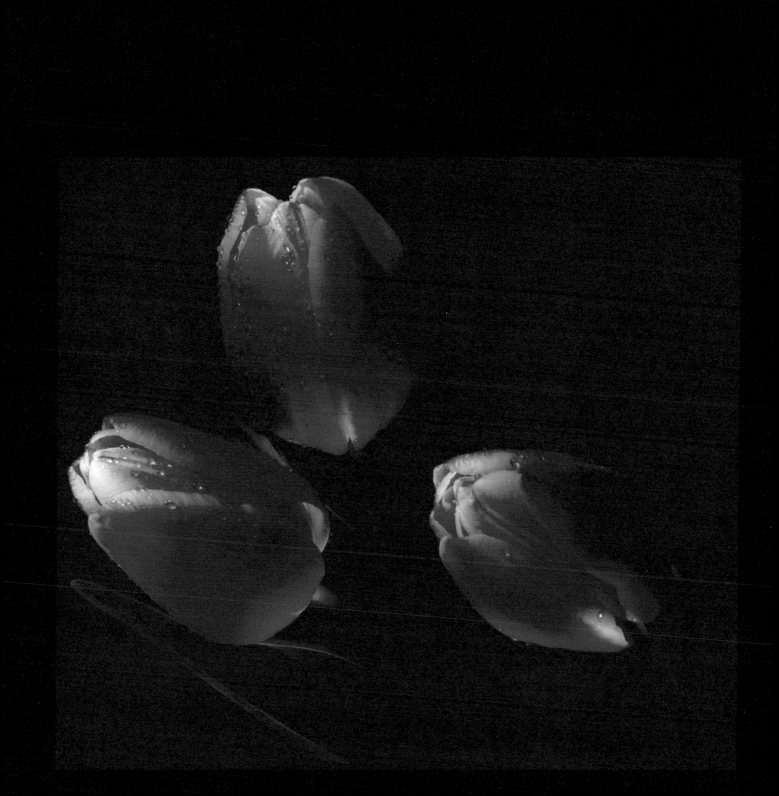

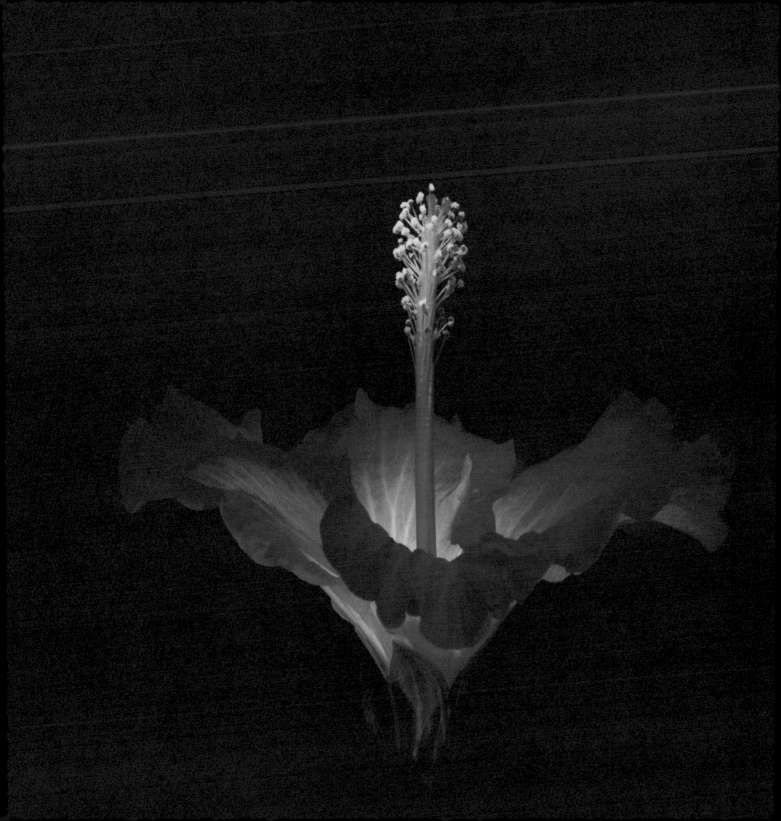

The Lord is my rock,

my fortress and my deliverer,

my God is my rock,

in whom I take refuge.

He is my shield and the horn of my salvation,

my stronghold.

Psalm 18:2

When I am afraid,

I will put my trust in you.

Psalm 56:3

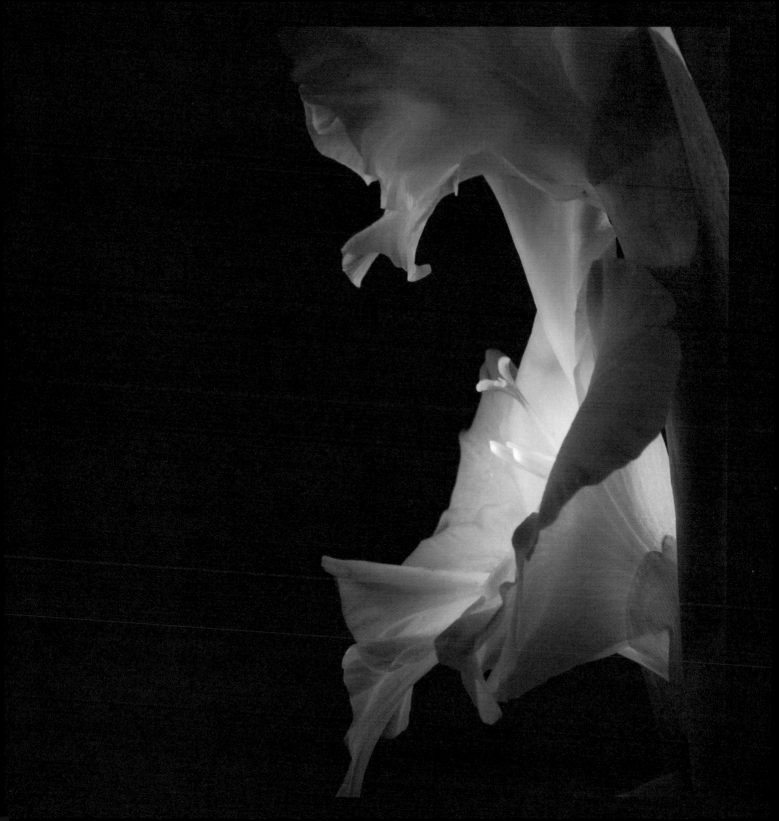

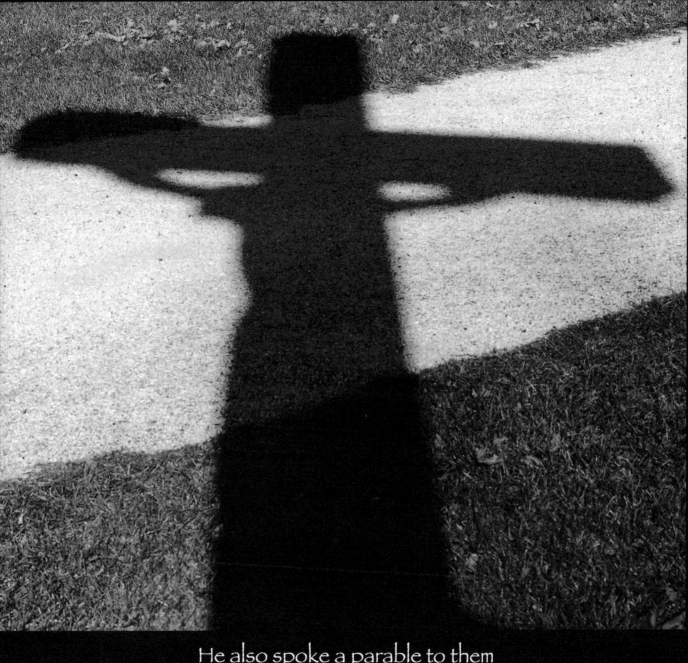

He also spoke a parable to them
that they should always pray
and never give up.

Again, therefore,
Jesus spoke to them saying
"I am the light of the world.
He who follows me
will not walk in the darkness,
but will have the light of life.

John 8:12

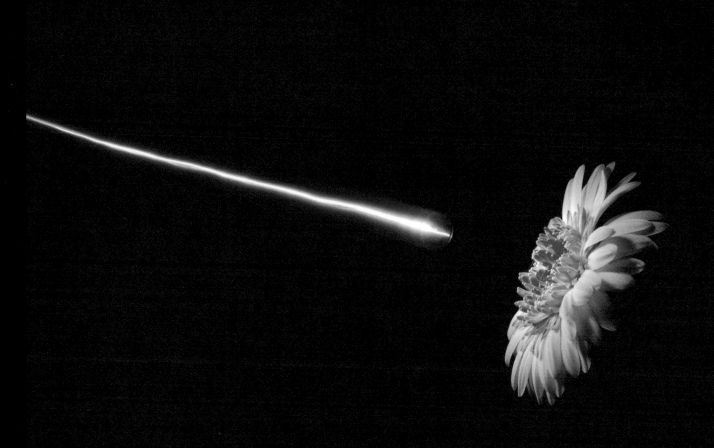

For with God

nothing will be impossible.

Luke 1:37

In my trouble
I cried to the Lord;
and he heard me.

Psalm 120:1

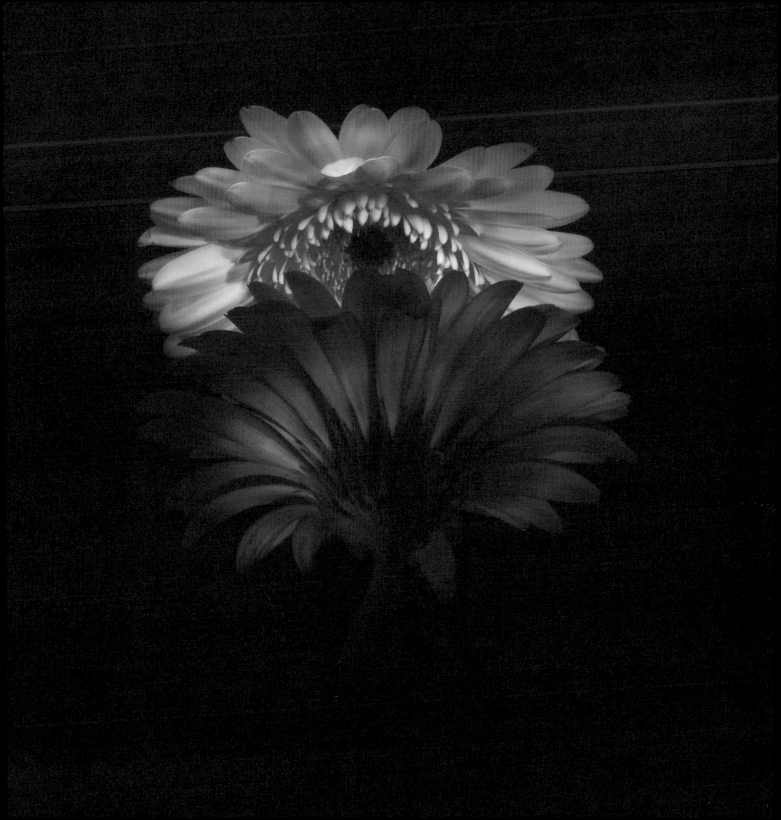

God is our refuge and strength,

an ever-present help in trouble.

Therefore we will not fear,

though the earth gives way

and the mountains fall into

the heart of the sea.

Psalm 46:1-2

Happy is the man who
finds wisdom
and the man who gets understanding.

Psalm 3:13

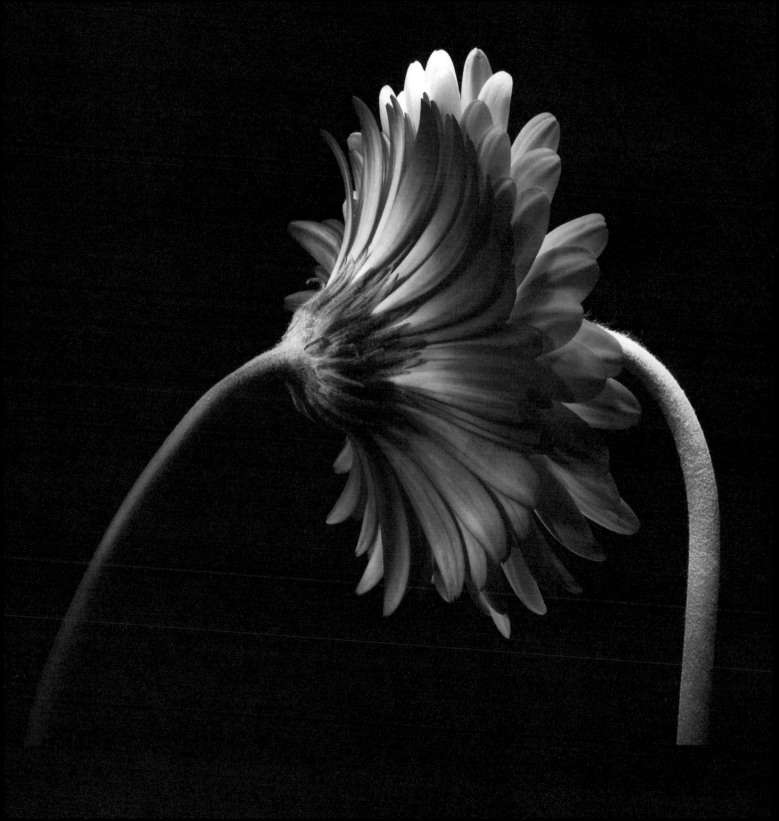

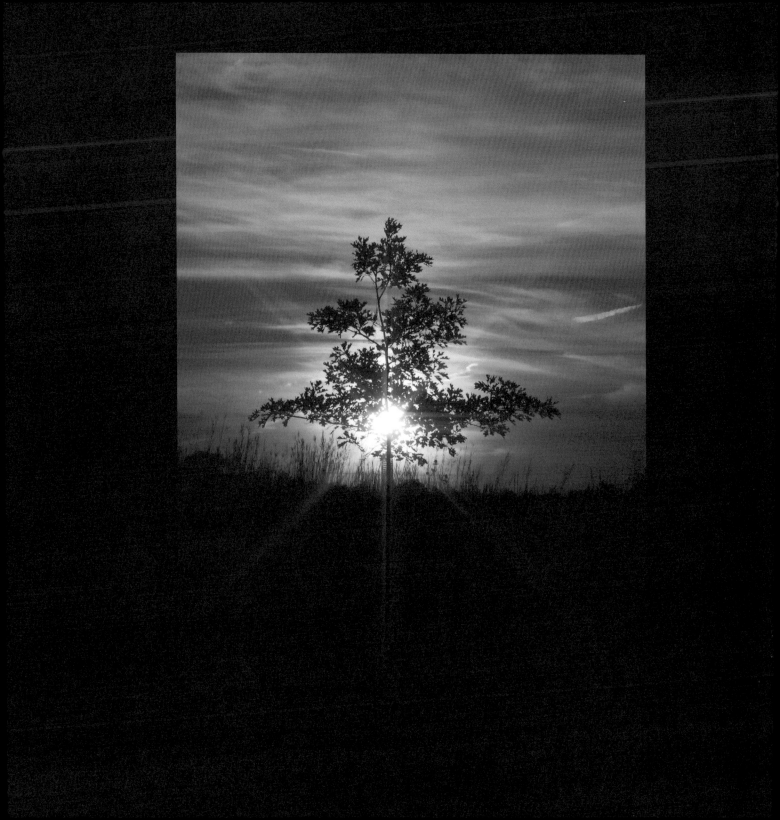

And he shall be like a tree

planted by the rivers of water,

that bringeth forth his fruit in his season;

his leaf also shall not wither;

and whatsoever he doeth shall prosper.

Psalm 1:3

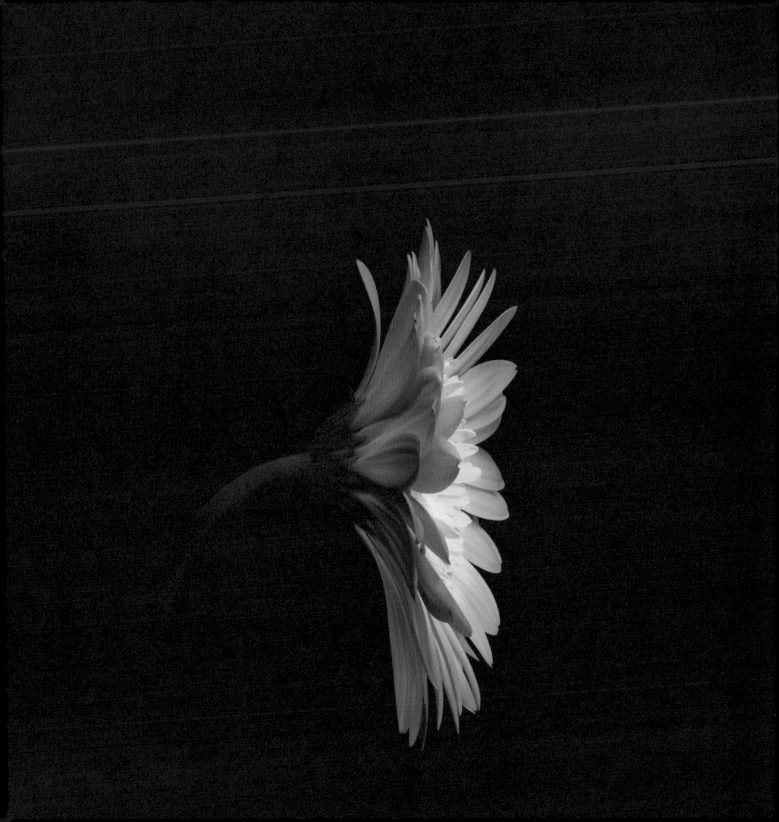

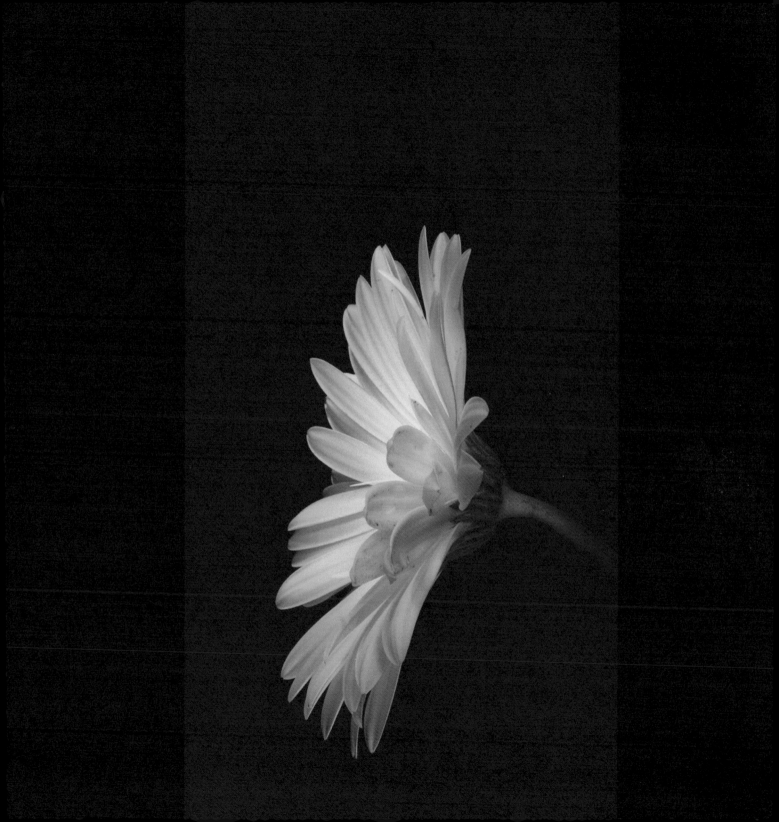

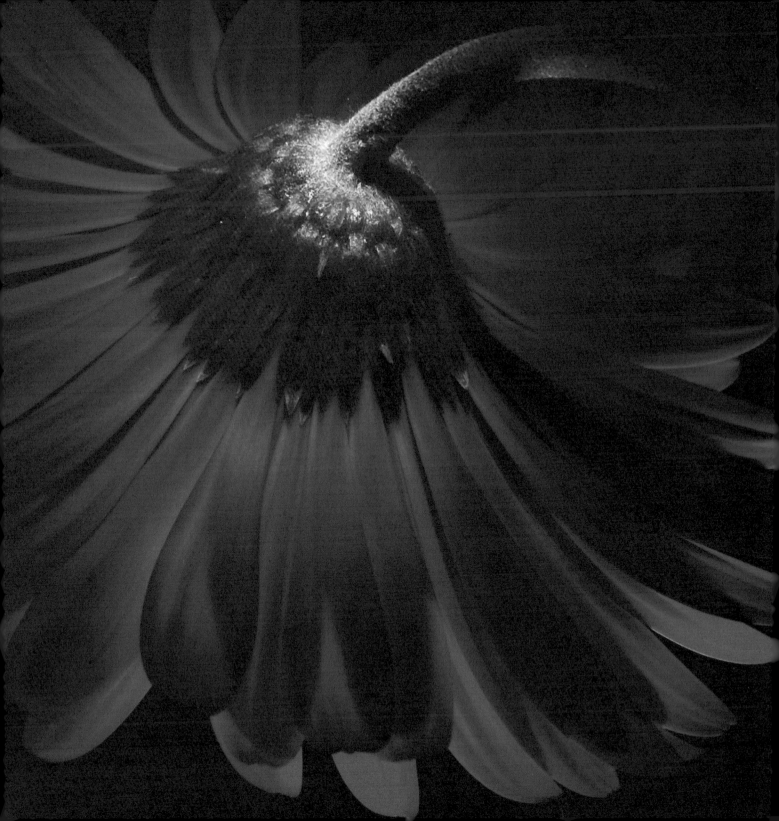

Peace I leave with you,

My peace I give to you:

not as the world gives

do I give it to you.

Let not your heart be troubled,

neither let it be afraid.

John 14:27

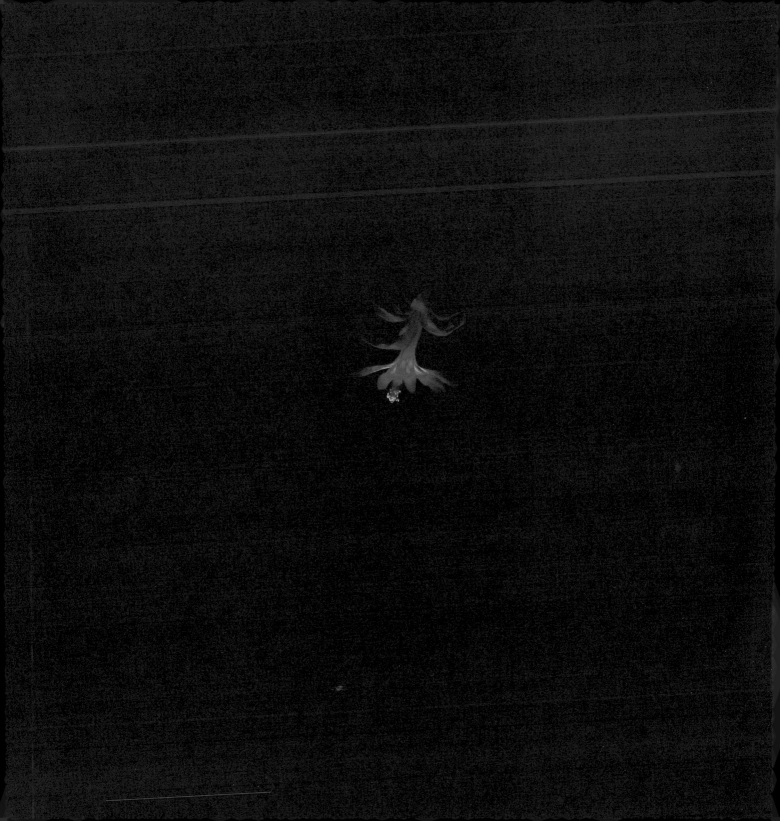

The Photographic Approach

These photographs were taken in a completely darkened studio with my Nikon D80 on a tripod. I try to get the smallest F/Stop (largest depth of field) and the slowest ISO (film speed) on manual or auto focus. The described setup gives approximately 15–20 seconds of exposure.

The lighting is done with a very small flashlight. I "paint" different sides, centers and edges with the light. Each bloom is unique in shape and color. The difficult part, for me, is remembering how I painted the last shot to improve the next. How much light, how close, and for how long is the fun part. I attempt to emphasize the beauty Nature has created.

This Christmas Cactus bloom is the first flower I photographed using the "painting" technique. I tried for three years to photograph this beautiful flower when it was in bloom but was not happy with the results. One afternoon, I again tried to photograph the red blossom but without success, so I left the tripod set up until late in the evening. When I returned that night, I thought, "What if?" and tried lighting it with a small flashlight. Four shots later . . . the photo that sparked the idea for this book.

I hope this information helps you enjoy the book.

Thomas Brain
April, 2011
http://www.thomasbrainphotography.com

CPSIA information can be obtained
at www.ICGtesting.com
Printed in the USA
LVIW010026020612

284365LV00002B